Digital Photography

New Turf for Printers

by David L. Milburn
with John L. Carroll

Graphic Arts Technical Foundation • Pittsburgh, Pennsylvania

*The main text of this book has been adapted from the series
"Digital Photography: New Turf for Printers?" first published
in GATFWorld, the bimonthly magazine published by the
Graphic Arts Technical Foundation.*

Cover photo provided by PGI Studios, Oklahoma City, Oklahoma

Graphic Arts Technical Foundation
200 Deer Run Road
Sewickley, PA 15143-2600
Phone: 412·741·6860
Fax: 412·741·2311
Email: info@gatf.lm.com
Internet: http://www.gatf.lm.com

TABLE OF CONTENTS

Foreward . v

1 Digital Photography Fundamentals 1
Area vs. Linear CCD Arrays .2
Image Capture Time .5
Array Size and the Cost of Resolution .7
Live Image Area vs. Image Capture Area .8
Image File Size and Resolution .12
The Missing Link .13
Tonal Resolution .14
Storing Image Files .15
Advice for Prospective Buyers .16

2 Tales from the Turf .19
Blanks Color Imaging .20
Quad/Photo, Division of Quad/Graphics, Inc.24
Primary Color .29
American Color .33
Summary .37

3 Management Considerations41
Aesthetic vs. Technical Orientations .43
The Integration of Photography and Printing44
Initial ROI Considerations .46
A Word of Caution .47
The Real Savings .51
New Responsibilities .52
What Will Drive Digital Photography? .52
Who Will Occupy the Turf? .53

Glossary .57

Further Readings . 61

About the Authors . 65

About GATF . 67

Other Books of Interest from GATF68

FOREWORD

Any printer who has picked up a trade journal or attended a conference during the last year will acknowledge that digital photography has received more than passing notice. Digital cameras and photography are becoming an increasing part of the world of advertising, promotional work, and web site design. Pioneering printers and graphics arts service providers who have launched digital photography ventures, some more successful than others, are telling their stories. Photojournalists are using digital cameras to capture major sporting events, such as the 1996 Summer Olympics. And digital photography is even beginning to hit the consumer market, especially in connection with personal or small business home pages on the Web.

The reasons for the surge of interest are compelling. The most often touted advantage is that digital photography can dramatically shorten prepress production time. In a properly calibrated installation, digital image files in CMYK format entirely bypass the scanning and color separation stages. Also, with digital photography, the wait for film processing—visual confirmation that an image has been properly captured—is no longer necessary. In studio situations, a digital camera tethered to an imaging workstation with a SCSI cable allows on-the-spot adjustments to lighting and composition. No extra dollars need be spent on bracketing exposures with multiple sheets of film or on maintaining an E-6 film processor. And there is no used chemistry to dispose of. Digital cameras are environmentally benign.

Of course, digital photography also insinuates itself rather well into the inevitable surge toward completely digital workflows that offer multiple output options, from ink on paper and on-demand printing to Internet and intranet publishing.

Digital photography can offer printers and graphic arts services providers the possibility of gaining a value-added service as well as a way to maintain their position in the prepress area with a

technology that some are predicting will replace scanning as the new digital imaging front end.

Digital photography, however, is still rather new and it merges technologies (photography and electronic prepress), production workflows, and business models in unfamiliar ways. We don't have all the answers yet, but it is more than time to pay attention to this new "turf," and it is for this reason that GATF offers this compilation of articles on digital photography that originally appeared in *GATFWorld*.

Digital camera technology has improved immensely since these articles were first published, and it continues to do so. Some things, however, have remained constant. Digital photography does not lend itself to a one-size-fits-all approach. It is especially important for those who want to venture onto this turf to know how they want to use digital photography and to know what it can and cannot do. This introduction to digital photography describes the options you should consider in order to avoid slashing a divot in your digital imaging turf.

Chapter 1 examines some of the digital imaging fundamentals and hardware configurations printers and graphics arts service providers need to consider before staking their claims in digital photography.

Chapter 2, "Tales from the Turf," offers the insights of four photographers who talk about their experiences with adding in-house digital photography services to existing prepress and printing operations.

Chapter 3 looks at some of the business considerations printers and graphic arts service providers need to evaluate in order to collect their "payoff on the turf."

Frances M. Wieloch
Editor, *GATFWorld*
July 1997

1 Digital Imaging Fundamentals

ARMED with digital cameras, growing numbers of entrepreneurial photographers have taken on the once arcane aspects of electronic prepress in an effort to deliver separated, ready-to-print digital image files that need only to be placed in a document layout program. Printers, color separators, and prepress trade shops are under siege. As digital photography becomes the preferred method for shooting product catalogs laden with photographic illustrations, demand for scanning and color separations has begun to wane.

Graphic arts professionals are feeling the pinch. As demand for prepress services declines, so follows market share and profit. One solution is to swim upstream and lure customers at the very beginning of the production cycle—offer digital photography as an in-house service that leads naturally to prepress and printing, all supplied by one vendor.

Quad/Graphics, Inc., of Pewaukee, Wisconsin was one of the first printers to adopt this strategy. The company's photographic division, Quad/Photo, was established in the mid 1980s prior to the advent of digital photography. When Leaf Systems was designing the first digital camera back in 1991, Quad/Photo became a logical choice for beta testing. Today, digital photography services account for 30% of the company's gross sales.

American Color, based in Phoenix, Arizona, also saw the potential of digital photography. With photographic facilities in six major cities and counting, all linked by a high-bandwidth wide-area network (WAN) for rapid file transfer, American Color has wasted little time putting digital photography to profitable uses.

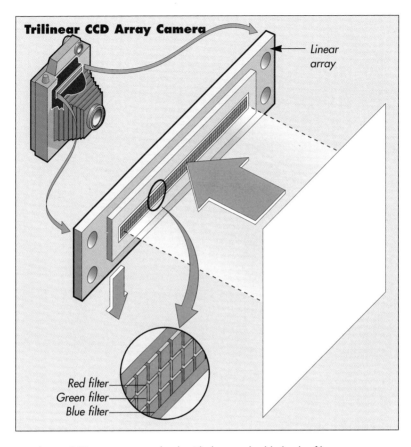

A trilinear CCD array camera back with three embedded color filters captures RGB data in a single pass, one row of pixels at a time. This design offers greater color accuracy because each pixel is made up of discrete red, green, or blue information. Since three rows of CCDs are used instead of an area array, with the remaining pixel positions recorded by scanning, ultra-high resolution can be had at an affordable price. Trilinear scanning backs are ill-suited for capturing movement since typical capture takes 3–10 min.

AREA VS. LINEAR CCD ARRAYS

Digital photography does not lend itself to a one-size-fits-all approach. Just as you wouldn't use a putter for a 200-foot drive, you can't use a scanning linear array digital camera when you need an area array field camera.

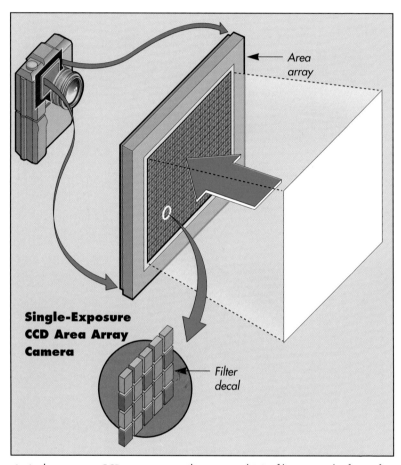

Area
array

Single-Exposure
CCD Area Array
Camera

Filter
decal

A single-exposure CCD area array utilizes internal RGB filtration in the form of decals positioned over the CCD surface. Each pixel in the array captures only red, green, or blue light, and the remaining two colors are interpolated. One exposure lasts a fraction of a second, making real-time image capture possible.

Current models of digital cameras/camera backs for graphic arts purposes are nearly all based on CCD (charge-coupled device) technology. The CCD image sensing elements are arranged in either a linear or an area array. A CCD linear array can be used to scan color images in one pass (a trilinear array) or in three passes (one for red, one for green, and one for blue). A CCD area array

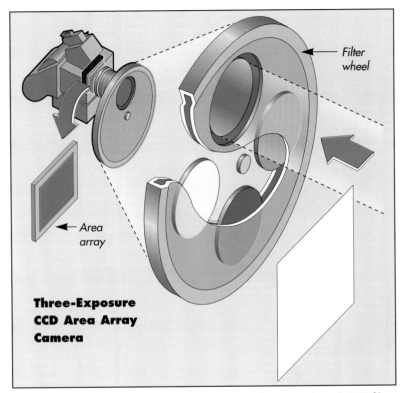

A three-exposure CCD area array captures image information through RGB filters positioned in a rotating wheel in front of the lens. As with the trilinear CCD scanning back, this design also permits discrete R-G-B capture for more accurate color rendition. Resolution is restricted due to the area array, but instantaneous capture makes it possible to work with electronic flash. Because image capture takes three exposures, moving subjects are precluded.

captures a color image in one or three exposures. Note: While digital cameras/camera backs are all designed to capture color images, some can also be used to capture images in black and white.

Each basic method of digital image capture has an appropriate category of subject matter. Broadly speaking, a linear array image capture device is designed for subjects that are stationary. Subjects that are moving require an image capture device based on a CCD area array.

The Kodak DCS 420 and Canon EOS•DCS 5 are typical field cameras, each using area array CCDs and single-exposure capture.
Courtesy Eastman Kodak Company

IMAGE CAPTURE TIME

Digital cameras/camera backs that use scanning CCD linear arrays require as long as 10 minutes to complete an RGB image capture. Area array cameras/backs that require three exposures to capture a color image also need time—up to 30 seconds. Consequently, in both cases, the subject must remain stationary until red, green, and blue image data has been captured.

This is not to say that digital photography cannot be used with moving subjects. Motion can be stopped with single-exposure area array cameras/backs. Photojournalists have eagerly embraced digital "field camera" designs for covering breaking news and sporting events. The Associated Press wire service has gained such confidence in digital imaging that, for the first time, 1996 Super Bowl coverage was provided entirely with digital cameras using no film backup.

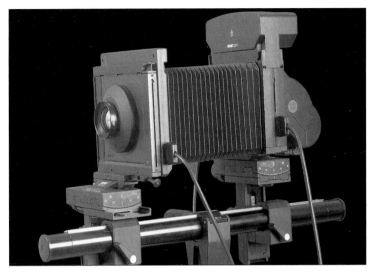

The Sinarcam studio camera from Sinar Bron Imaging uses an area-array CCD and three-shot color capture.
Courtesy Sinar Bron Imaging

Digital cameras in the "field camera" category most often utilize CCD area arrays in combination with internal RGB filtration. This design facilitates image capture in a fraction of a second, but writing the RGB image data to disk requires 3–10 seconds. These cameras can capture movement, but sequential motion is problematic due to image write time.

Cameras, or more often, digital camera backs, that use trilinear scanning arrays typically produce ultra-high-resolution file sizes that are well-suited to commercial studio photography, artwork reproduction, and applications where high-quality reproduction is critical. Area array cameras and backs that take three exposures to capture a color image produce moderate file sizes that better lend themselves to high-volume image production such as catalog product illustration.

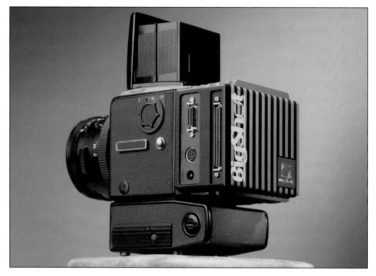

The Dicomed BigShot, with a typical medium-format back, using an area-array CCD for single-exposure color capture.
Courtesy Dicomed, Inc

ARRAY SIZE AND THE COST OF RESOLUTION

When and how CCD linear or area arrays are used in digital cameras and camera backs has evolved in response to cost issues. A trilinear scanning array, for instance, can offer higher resolution at a lower cost for studio work. Only three rows of pixels—one each for red, green, and blue, running the width of the image capture area—are necessary to obtain ultra-high-resolution from a trilinear array scanning back such as the Dicomed 7520 SE or the PhotoPhase Plus. During an exposure, the trilinear array moves slowly across the film plane, recording light intensity at a predetermined number of pixel positions and writing image information as a stream of digital data to the hard drive. The capture process takes roughly three minutes at maximum resolution. Although the completed RGB image file contains data from 45 million pixel positions, the number of pixel elements required to scan the image capture area is less than 5 million.

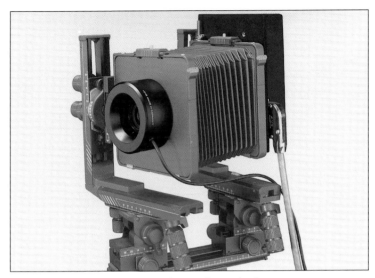

The MegaVision T2, with a typical 4 × 5 format back, using an area-array CCD and three-shot color capture.
Courtesy MegaVision, Inc.

Because of the scanning ability of the trilinear array, the cost of an ultra-high-resolution camera back is less than $25,000. If 45 million individual pixel elements were required for the trilinear CCD array, costs could easily exceed $200,000!

From this example, it is apparent that CCD area arrays are necessarily small to keep cameras that use them affordable. The most common size for area arrays used in field cameras is 1,524 × 1,012 pixels. These dimensions make it possible to keep the price between $10,000 and $15,000. Kodak's high-resolution field camera, the DCS 460, contains a CCD array with four times this number of pixels. It is priced accordingly at $27,995.

LIVE IMAGE AREA VS. IMAGE CAPTURE AREA

In addition to cost, the CCD array size also determines the size of the image capture area. With a CCD array, the image capture area tends to be smaller than the film format for which the camera, or film back, was initially designed. For example, a 35-mm camera

has a 24 × 36-mm live image area with silver halide film, but with CCDs the live image area shrinks to 8 × 12 mm. The same size discrepancy is true for the popular 2,048 × 2,048 pixel array used in the Leaf DCB II, the MegaVision T2, and others. The potential live image area for medium-format cameras like the Hasselblad is 6 × 6 cm, while the CCD array measures 35 × 35 mm. The lone exception to this format difference is the Dicomed BigShot camera back with a CCD area array that measures 6 × 6 cm. [The Dicomed BigShot is now available.]

The difference in size between a CCD array and the film format of its host camera creates two major problems for photographers. One is that the image seen in the viewfinder, or on the ground glass, is larger than the live image area and must be cropped to accurately display the angle of view corresponding to the CCD image capture. With the viewing area cropped to 25% or less of its original size, arranging the compositional elements that make up the intended subject is a feat in itself.

A second problem is that the reduction in live image area that creates a more narrow angle of view has the effect of increasing lens focal length by a factor ranging from 2 to 2.6. For example, a 50-mm lens placed on the Kodak DCS 420 or Canon EOS-DCS 5 becomes a 130-mm lens. To compensate, a 20-mm lens is needed to approximate the normal angle of view. With medium format cameras that use the 2,048 × 2,048 pixel CCD array, a normal focal length lens of 80 mm becomes a medium length telephoto lens of 160 mm. A 40-mm wide-angle lens is needed to provide the normal angle of view.

Cameras designed from the ground up for digital image capture offer an advantage here in that their viewfinders are designed for full-frame viewing. Cameras of this ilk include the Fujix DS 505 and DS 515 and the Nikon counterparts, E2 and E2s. With these models, a 50-mm lens provides the same angle of view displayed by a film-based 35-mm SLR. The photographer is not plagued by a cropped viewfinder.

DIGITAL CAMERAS/BACKS FOR GRAPHIC ARTS PURPOSES — FEATURES

MODEL & MANUFACTURER	MAX RESOLUTION	BIT DEPTH*	TYPE OF CCD	PROCESSING TIME
Action Cam, Agfa Bayer	1,528 x 1,146	36 bit/24 bit	Area array	3-second cycle
Studio Cam, Agfa Bayer	4,500 x 3,648	36 bit/24 bit	Trilinear array	10 min. at max. res.
EOS•DCS 5, Canon & Kodak	1,524 x 1,012	36 bit/24 bit	Area array	2.3 frames/second
EOS•DCS 3, Canon & Kodak	1,268 x 1,012	36 bit/24 bit	Area array	2.7 frames/second
EOS•DCS 1, Canon & Kodak	3,060 x 2,036	36 bit/24 bit	Area array	2 frames/8 seconds
7520 SE, Dicomed	7,520 x 6,000	36 bit/24 bit	Trilinear Array	3 min. at max. res.
BigShot, Dicomed	4,096 x 4,096	36 bit/24 bit	Area array	10-second cycle
DS 515, Fuji	1,280 x 1,000	30 bit/24 bit	Area array	3 images/second
DS 505, Fuji	1,280 x 1,000	30 bit/24 bit	Area array	1 image/second
DGA System, KanImage	3,072 x 2,320	36 bit/24 bit	Trilinear array	2 sec. to 36 sec.
DCS 410, Kodak	1,524 x 1,012	36 bit/24 bit	Area array	2-second cycle
DCS 420, Kodak	1,524 x 1,012	36 bit/24 bit	Area array	2-second cycle
DCS 460, Kodak	1,524 x 1,012	36 bit/24 bit	Area array	2 frames/second
DCS 465, Kodak	3,060 x 2,036	36 bit/24 bit	Area array	2/8-second cycle
Lumina, Leaf	3,380 x 2,700	36 bit/24 bit	Trilinear array	1-3 min. at max. res.
Catchlight, Leaf	2,048 x 2,048	42 bit/24 bit	Area array	2-second cycle
DCB II, Leaf	2,048 x 2,048	42 bit/24 bit	Area array	20 seconds
SinarCam, Sinar Bron	2,048 x 2,048	42 bit/24 bit	Area array	4 frames/second
T2, MegaVision	2,048 x 2,048	36 bit/24 bit	Area array	3/10-second capture
T3, MegaVision	2,048 x 2,048	36 bit/24 bit	Area array	1.5/2-second cycle
RD 175, Minolta	1,528 x 1,146	36 bit/24 bit	3 Area arrays	Real time
E2Ns, Nikon	1,280 x 1,000	30 bit/24 bit	Area array	3 images/second
E2N, Nikon	1,280 x 1,000	30 bit/24 bit	Area array	1 image/second
Photo Phase Plus, Phase One	7,142 x 5,000	36 bit/24 bit	Trilinear array	3 min. at max. res.
Carnival 2000, Scanview	2,048 x 2,048	36 bit/24 bit	Trilinear array	30-second cycle
DKC-5000, CatsEye Sony	1,520 x 1,144	30 bit/24 bit	3 Area arrays	Real time
DKC-ST5, Sony	2,560 x 2,048	30 bit/24 bit	Progressive scan	Real time

	COLOR CAPTURE	FILE STORAGE	CONFIGURATION	LIST PRICE	DISTRIBUTOR
Action Cam, Agfa Bayer	Single-exposure	PC card	Field camera	$9,499	Vision Group
Studio Cam, Agfa Bayer	Scanning	Depends on host	Studio camera	$9,499	800-685-4271
EOS•DCS 5, Canon & Kodak	Single-exposure	PC card (Type III)	Field camera	$10,995	Canon, USA 516-488-6700
EOS•DCS 3, Canon & Kodak	Single-exposure	PC card	Field camera	$16,995	and
EOS•DCS 1, Canon & Kodak	Single-exposure	PC card	Field camera	$27,995	Eastman Kodak 800-235-6325
7520 SE, Dicomed	One-pass scan	Internal 1-GB drive	4 x 5 format back	$22,500	800-888-7979
BigShot, Dicomed	Single-exposure	Depends on host	Medium format back	$54,900	
DS 515, Fuji	Single-exposure	PC card (Type I)	Field camera	$16,710	800-378-3854
DS 505, Fuji	Single-exposure	PC card (Type I)	Field camera	$13,640	
DGA System, KanImage	One-pass scan	Depends on host	Studio camera	$36,000	718-482-1800
DCS 410, Kodak	Single-exposure	PC card (Type II or III)	Field camera	$7,995	Eastman Kodak
DCS 420, Kodak	Single-exposure	PC card (Type III)	Field camera	$10,995	800-235-6325
DCS 460, Kodak	Single-exposure	PC card (Type III)	Field camera	$27,995	716-724-4000
DCS 465, Kodak	Single-exposure	PC card (Type III)	Medium format back	$19,995	
Lumina, Leaf	One-pass scan	Depends on host	Studio camera	$4,999	DTP Direct 800-762-3531
Catchlight, Leaf	Single-exposure	Depends on host	Medium format back	$27,900	Sinar Bron
DCB II, Leaf	Three-shot color	Depends on host	Medium/large format back	$27,900	800-456-0203
SinarCam, Sinar Bron	Three-shot color	Depends on host	Studio camera	$43,500	
T2, MegaVision	Three-shot color	Depends on host	4 x 5 format back	$24,750	805-964-1400
T3, MegaVision	Single-exposure	PC card (Type III)	Medium format back	$19,800	
RD 175, Minolta	Single-exposure	PC card	Field camera	$7,995	800-964-6658
E2Ns, Nikon	Single-exposure	PC card (Type II)	Field camera	$14,880	800-526-4566
E2N, Nikon	Single-exposure	PC card (Type II)	Field camera	$9,995	
PhotoPhase Plus, Phase One	One-pass scan	Depends on host	4 x 5 format back	$23,470	800-972-9909
Carnival 2000, Scanview	Three-shot color	Depends on host	Studio camera	$29,995	415-378-6360
DKC-5000, CatsEye Sony	Single-exposure	Depends on host	Studio camera	$15,100	800-427-7669
DKC-ST5, Sony	Single-exposure	Depends on host	Studio camera	$31,500	

For digital camera backs used on 4×5 studio cameras, such as the Dicomed, PhotoPhase, and particularly the Leaf DCB II, another complication arising from differences between focal length affects the use of camera movements. As lens focal length increases because of the narrow angle of view with smaller CCD arrays, the ability to use camera movements becomes more restricted. Camera movements are commonly used with still life subjects to minimize visually annoying distortions and to reposition depth of field boundaries along the most desirable plane of the subject.

IMAGE FILE SIZE AND RESOLUTION

File size is important for determining if an image can be printed at a desired level of quality with a specific screen ruling.

To calculate the size of an image file produced by a digital camera, first multiply the horizontal and vertical dimensions of the CCD linear or area array. The product of these numbers is the file size for a single-channel or a black-and-white rendition. For RGB image capture, multiply the file size for one channel times three. For example, the file size for a single channel for the Kodak DCS 460, with a resolution of $3,060 \times 2,036$ pixels, is just over 6 MB. For an RGB rendition, multiply 6 MB by 3 to yield an 18-MB file.

Taking these calculations a step further, we can determine if the file size is sufficient to yield a desired level of quality at a specific screen ruling. With the 18-MB file as an example, let's determine if there is enough pixel information to output a 5×7-inch image at a 200-line screen ruling. To maintain high quality in accordance with the Nyquist Criterion, there must be two pixel samples per each line of resolution. This requires a minimum image resolution of 400 dots per inch (dpi). If we multiply the image dimensions by 400 dpi, the resolution must be $2,000 \times 2,800$ dpi for a total minimum file size of 5.6 MB per channel. So, the original file size of 6 MB per channel is more than enough to maintain the desired quality standard.

The Missing Link

Digital cameras have yet to provide a key ability—high-resolution, single-exposure RGB image capture with split-second write time. Certainly, a handful of vendors, in addition to Dicomed, are striving mightily to sink this putt. Camera backs with this feature are likely to slow the trend of digital cameras being used mostly for niche work because of their technological limitations. Portrait and studio photographers alike will find an ultra-high-resolution single-exposure digital camera back very appealing.

Photographers who are currently using trilinear scanning backs, such as the Dicomed 7520 SE or PhotoPhase Plus, would welcome a chance to work with familiar electronic flash lighting, the studio standard. To accommodate the trilinear scanning backs currently in use, it is necessary to use high-intensity flicker-free lights that generate prodigious amounts of heat. This makes it difficult to control lighting nuances. Because scanning backs typically require 3–10 minute exposure times, the irregularities in 60 Hz alternating current line frequency that go unnoticed with shorter exposures become increasingly problematic with longer exposure times. Small fluctuations in voltage, as frequent as several times per minute, may cause small changes in lumen output and gray balance. During extended image capture, the light intensity affected by these variations is manifested as banding in the image. To alleviate this problem, some manufacturers are packaging lighting and backs together so that lighting is flicker free.

David L. Milburn

To determine if the image can be printed at 200 lines per inch (lpi) with at least 256 levels of gray (for 8-bit color rendition), use the following formula: (Resolution ÷ Screen Ruling)2 + 1 = Number of Gray levels.

An imagesetter or platesetter resolution of 3,600 dpi divided by a screen ruling of 200 lpi gives $18^2 + 1 = 325$ levels of gray. At best, the human eye sees about 200 shades of gray, so 325 is plenty.

TONAL RESOLUTION

The term "resolution" is most often used in the graphic arts to refer to spatial addressability in horizontal and vertical dimensions. Digital cameras and scanners also measure "tonal resolution," which is the number of bits of color or grayscale information that can be recorded per pixel.

Eight-bit cameras and scanners can record 256 colors or levels of gray per pixel. Many recently introduced digital cameras gather 12 bits of tonal resolution per RGB channel. And one manufacturer, Leaf Systems, claims 14 bits of tonal resolution.

The terms "24-bit color" or "36-bit color" refer to the three channels needed for RGB. The advantage of greater bit depth, or tonal resolution, is that a photographic image can be reproduced with a larger number of intermediate tones or colors. This provides a more photo-realistic rendition and minimizes the risk of banding in regions with smooth tonal gradations. When a 36-bit image file is reduced to 24-bits on a desktop computer, the extra bit data is useful in compensating for image artifacts, particularly in deep shadows where detail is more difficult to render.

In relation to silver halide film, bit depth equates to the length of the tonal scale. A longer scale can capture an image with a broader tonal range without cutting off highlight or shadow detail. With digital image capture, a computer-generated histogram is the best indicator of whether a photograph has been correctly recorded. If the histogram displays a full range of tones including highlights and shadows, the exposure used to capture the image is "normal." If highlight detail is missing and shadow detail is fully rendered, the image capture corresponds to an overexposure on transparency film. If shadow detail is missing and highlight detail is fully rendered, the image capture corresponds to an underexposure on transparency film.

STORING IMAGE FILES

Digital images require considerable file storage capacity, an issue you need to consider along with that of internal, and perhaps external, file transmission.

Digital camera backs designed for studio use are linked to a computer workstation by means of a SCSI (small computer systems interface) cable. With many backs, particularly those with ultra-high-resolution capability, storage for captured image files is provided by the computer's internal hard drive or a dedicated external drive. Minimum requirements for working with 12-MB image files are approximately 64 MB of RAM and 300 MB of hard disk storage. These specifications easily quadruple for large image files.

With handheld digital cameras, an image file is typically stored on an internal hard drive or a removable PC card (formerly called PCMCIA cards). PC cards are the storage method of choice for the Kodak Professional Digital Camera lineup (EOS-DCS 5, DCS 420, DCS 460, and DCS 465) and the Nikon and Fujix digital cameras. Because there are Type I, Type II (flash memory PC cards), and Type III (hard-disk PC cards), compatibility between brands is not necessarily assured. Microtech makes a PC card reader, called the Digital PhotoAlbum, that accepts cards of the latter two types.

Unlike trilinear scanning backs that write RGB data to a hard drive as they traverse the live image area, single-exposure backs that capture RGB image data in a fraction of a second are subject to the bottleneck of data transfer to disk or PC card in order to make way for the next exposure.

File size is the limiting factor that determines how quickly an image can write to disk. With the 18-MB files produced by the Kodak DCS 460, two images can be captured in two seconds, but an eight-second pause is required to store each image. In comparison, the 4.5 MB file size generated by the Kodak DCS 420 makes possible bursts of five frames over a span of several seconds followed by a two- or three-second pause to write to disk.

ADVICE FOR PROSPECTIVE BUYERS

Prior to making a purchase, ask the vendor what additional equipment you need to make a particular camera or digital back functional. Turnkey packages are few and far between. Study the models that are designed for your application and don't make any assumptions.

The purchase price of a digital camera frequently includes only a digital camera back or camera body, software, and cables. You will need to purchase a host camera and lenses if you buy a digital camera back.

For studio cameras, determine in advance what minimum workstation specifications are required for smooth operation. Find out specifically what cables are needed to interface the camera with the workstation. Cable length is a frequently overlooked factor.

Field cameras, such as the Kodak DCS models, require SCSI cables with a six-foot maximum length if you intend to operate them from a workstation. Some digital camera backs are tethered with SCSI II cables that permit working distances of 15 to 20 feet between camera and computer.

In examining the features presented by the current generation of digital cameras, the most important consideration to keep in mind is that these seemingly exotic machines are targeted at small niche markets. If the intended use for a digital camera is not absolutely clear to you, delay your purchase until you have answered this key question. A digital camera back with a scanning trilinear array can no more easily be used for portraiture than a driver can be used to sink a 60-foot putt.

2 Tales from the Turf

MARKETS for digital photography continue to evolve, but those currently holding the best prospects for graphic arts professionals are linked to catalog production. While the subject matter may range from small-product still life to most recently fashion, the draw is the volume of images produced. Digital photography's collapsed throughput time easily justifies its use for image-intensive publications. The elimination of scanning and color separation, coupled to the certainty of having high-quality image files without need for film verification, are convincing arguments for the viability of this new medium.

As with the implementation of any new technology, several obvious questions come to mind. Who are the major players and what accounts for their success? What are the primary obstacles they had to overcome? What are the advantages of this technology and how have they contributed to the profit-making potential? What equipment are they using and how are they using it? And what about customer response, technical problems, proofing, and personnel issues.

Tracey Conant of Blanks Color Imaging, Jeff Koser of Quad/Photo, Martin Brower of Primary Color, and John Carroll (now an independent consultant) of American Color offer some practical insights into these and other questions in the following "tales from the turf."

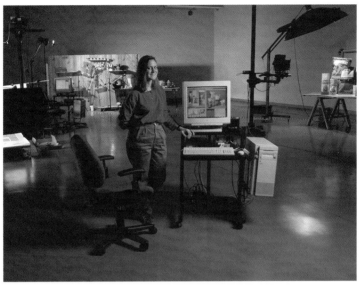

"Digital photography forces you to light and shoot for the way you want an image to look when printed with four-color process. A built-in software densitometer serves as a spotmeter and a CMYK preview in ColorShop enables a quick double check before converting RGB to CMYK."

Tracey Conant, Blanks Color Imaging,
Dallas, Texas.

Tracey Conant's digital photography studio at Blanks Color Imaging is furnished with two Leaf Digital Camera Back IIs mounted on Sinar T 455-in. view cameras linked to Macintosh Quadra 950 workstations. Behind and to the right are two still-life sets in production. The one on the right has been photographed, and the image capture is displayed on the monitor in the foreground.

BLANKS COLOR IMAGING

Blanks Color Imaging, Dallas, Texas, began offering digital photography services to its customers in 1993 with the installation of a Leaf Digital Back mounted on a Hasselblad medium-format camera. After consultation with True Redd, a Dallas-based advertising photographer, this camera was swapped for a 4 × 5-in. Sinar T monorail view camera so that corrective movements could be made for still-life product subjects. To compensate for the focal length

discrepancy between the 3×3-cm CCD array and the 4×5-in. conventional film format, Sinaron lenses in 40, 60, 80, 110 and 135 mm focal lengths were selected for studio use in lieu of standard focal lengths, such as 210, 240 and 300 mm, for the 4×5-in. film format .

In addition to equipment acquisitions, Blanks Color Imaging hired Redd's former assistant, Tracey Conant, to redouble their digital photography efforts. She is using her understanding of product lighting techniques to distinguish Blanks' photography from the competition. Conant contends that photography and color separation require distinct job skills, and since digital image creation demands her complete attention, she prefers to leave color correction tasks to the electronic color retouchers.

Although most shooting with Blanks' two digital cameras is for catalog production, Conant says they also have steady use for making last-minute shots needed to complete advertising projects. Digital image capture can be a time-saver in the face of looming deadline pressure, because there is no need to wait for film processing or scanning, she added. Previews on the workstation monitor tell the art director whether a shot has the right look. Conant states that 95% of Blanks' photography work is shot with digital cameras. When it is necessary to stop motion, as with fashion models or with special lighting techniques, conventional film is used.

To avoid potential quality loss resulting from interpolation of digital image files, Conant prefers to shoot at a resolution that supports the finished image size, typically Res 12 or 300 lpi, which results in a 16-MB file. At this resolution, 13×13-in. image dimensions are feasible. Before saving the images as RGB/TIFF, Conant exports them to Leaf's ColorShop software for analysis of their histograms. With this visual display, she said she can quickly determine how thoroughly highlight and shadow detail have been captured and whether any exposure or lighting adjustments are needed. The image is then saved in CMYK/TIFF or, more commonly, Scitex CT format, and transferred to the electronic prepress department on an 8-GB hard drive shuttle. Some clients prefer to make their own corrections on the high-resolution CMYK/TIFF files, but most are

To determine what printers, color separators, and prepress trade shops are involved in the digital photography, we turned to Pre magazine's annual survey (November/December 1995) of the top 100 prepublishing companies, ranked according to their 1994 prepress sales. Defying conventional wisdom, we started in the middle of the pack and worked toward the top. After preliminary interviews with roughly a dozen companies, we settled on Quad/Photo, ranked 8th; American Color, ranked 9th; Blanks Color Imaging, ranked 18th; and Primary Color, ranked 36th. This provided a good geographical dispersion as well as a range in size based on sales volume from $12.8 to $78.1 million. Interestingly, of Pre magazine's top 100 prepublishing sites, the first seven do not offer in-house digital photography services.

■ Blanks Color Imaging, established in Dallas, Texas, in 1940, had a 1994 sales volume of $24.2 million. The three divisions of the company—National Catalog, Packaging and Design, and Southwest Advertising—are housed within a single 87,000 ft2 facility. Blanks is a full-service supplier. Specializations include color separation, sheetfed printing, and flexo prepress.

■ Quad/Photo is a division of Quad/Graphics. With a central facility in Pewaukee, Wisconsin, Quad/Graphics was started in 1971 by Harry Quadracci. Today the business includes 11 locations in major U.S. cities with 800 employees and a 1994 sales volume of $78.1 million. Quad/Graphics provides services to the magazine, catalog, FSI and commercial products markets. The company provides complete production services beginning with design and photography through finishing, mailing and distribution.

■ Primary Color, a relative newcomer to the graphic arts arena, is located in Irvine, California. A trade shop with $12.8 million in 1994 sales and facilities at two locations, Primary Color focuses on high-end color prepress work which includes scanning, color correction, retouching, film output, and digital photography. During the last several years, the company has also moved into multimedia and CD-ROM production.

■ American Color, a trade shop based in Phoenix, Arizona, is now in its 22nd year of operation. With 840 employees and $76.1 million in 1994 sales, the company provides prepress services to printers, publishers, retailers, and catalog sales organizations across the United States, including Macintosh and PC desktop services, color separation, multimedia, digital archiving, and, of course, digital photography.

content to work with low-resolution placement files, says Conant. So far, Blanks' archival storage system consists of approximately 100 1.2-GB optical disks. Since hard drive space on her two Quadra 950 workstations is limited, she and her assistant save new images directly to the optical disks.

For proofing digital photographs, Blanks uses the Kodak Approval System, which produces electronically generated halftone dots. Conant initially used a continuous tone proofing system, but said she had difficulty achieving consistent results. The Approval proofs are used for intermediate production stages and final proofs.

Regarding customer response to digital photography, Conant says an art director's reluctance to use digital image capture is usually based on two concerns, both related to quality. The first is the misconception that the physical attributes of a digital photograph, primarily resolution and color rendition, may fall short of a film-based image. The second is the perception that using an unfamiliar photographer with digital capability is too risky relative to the consistent quality delivered by an established photographer who still shoots film.

With first-time customers, an apprehensive art director is nearly always present during the shoot, said Conant, but repeat clients with bolstered confidence levels frequently ship merchandise for the shoot to Blanks Color Imaging unaccompanied by an art director. Commenting on the Dallas-area photographic community, Conant observed that few photographers are investing in digital photography equipment, but printers have shown greater initiative.

QUAD/PHOTO, DIVISION OF QUAD/GRAPHICS, INC.

Quad/Photo, a division of Quad Graphics, began its involvement with digital photography in late 1991, when Leaf Systems asked the studio to beta test the prototype of the Leaf Digital Camera Back (Leaf DCB). Jeff Koser, director of digital photography, says Quad/Photo began testing the new design in January 1992. Digital photography files were handed off to the electronic prepress department so that technicians could educate themselves about preparing digital image files for film output. Since the Leaf back was intended for beta testing, Quad/Photo felt no urgency to begin using it for customer jobs.

A year later, after careful analysis and manipulation of the Leaf DCB's tone reproduction curves to achieve digital files of consistent quality, Koser and his staff decided to introduce the digital camera to a handful of clients as a viable production option. According to Koser, these customers all shared an important trait—they were receptive to new technologies and willing to consider alternative workflows. Since the Leaf DCB uses a three-pass RGB exposure system, it was also necessary that subject matter be limited to tabletop still-life products. Using the Leaf DCB as an attachment for its existing view cameras, Quad/Photo found that photographers could quickly move between 4 × 5-in. sheet film and digital image capture, making it relatively easy to shoot a still life with both media for the sake of comparison.

One major factor that eased the transition from film to digital image capture, was Quad/Photo's already existing implementation of measured photography techniques, reported Koser. Measured photography is based on the concept of producing photographs with a tonal range matched to that of the reproduction system. Instead of using the full tonal range afforded by photographic transparency film and producing an image that needs significant tone compression to reproduce well, only a restricted portion of the potential tonal range is used. By considering the tonal range limitations of the reproduction system, the photographer can pro-

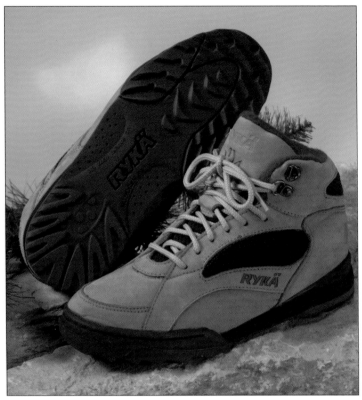

This digital image capture of hiking boots was shot with the Leaf Digital Camera Back II in Quad/Photo's Pewaukee, WI studio. Still-life product photographs such as this are ideally suited for digital cameras that capture RGB data in three separate exposures.

duce photographs with restricted tonal ranges that require minimal tone compression and reproduce with relative ease.

Presently, Quad/Photo has three digital camera installations. The Leaf DCB is in use at both its Boston, Massachusetts, and New York City locations. The Pewaukee, Wisconsin, studio is equipped with a MegaVision T2 digital camera. Although T1 transmission lines link these locations and facilitate rapid transfer of digital image files, each location has design, photography, prepress, and printing capabilities that give it a high degree of autonomy.

"Our biggest hurdle is overcoming a constant comparison with film. Digital photography needs to be recognized as its own medium with its own characteristics, many of which transcend film."

Jeff Koser, Quad/Photo, division of
Quad/Graphic,
Pewaukee, Wisconsin

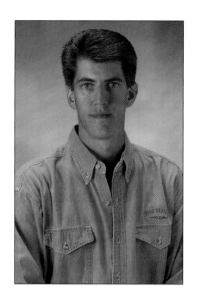

What makes this deftly executed portrait of Jeff Koser unique is that it was photographed with the Leaf Digital Camera Back II utilizing three individual exposures through red, green and blue filters. Koser adjusted the RGB filter wheel to cycle as quickly as possible, which required that he pose motionless for seven seconds.

Koser pointed out that some clients use only Quad/Photo's photography capabilities, and do not take advantage of the company's expertise in preparing image files for prepress in accordance with in-house tone reproduction curves and look-up tables. Because other prepress shops and printers lack similar internal controls, said Koser, they must work to wider tolerances to allow for a greater margin of error. And this situation, he noted, leads to diminished product consistency.

Quad/Photo's digital image files average 8 MB in RGB/TIFF format. After conversion to CMYK in Scitex CT format, the file size increases slightly to 10 MB. Note that the Leaf DCB makes an initial 24-MB image capture with 14 bits per channel of dynamic range, but once the image is imported to a Macintosh workstation, it is limited to 12 MB with 8 bits of dynamic range per RGB channel.

When asked about his greatest challenge in establishing digital photography for Quad/Photo, Koser replied that contending with customer expectations is a larger obstacle than that posed by the integration of new technologies. Many clients are put off by not having a hard copy original for visual reference, he said, and some customers need digital transparency outputs for end uses unrelated

to printing. The cost of producing digital transparencies with a film recorder often negates the monetary savings that digital photography could have given the client. In an effort to minimize these problems, Quad/ Photo sells its digital photography with a contract proof of each shot as part of the package. Contract proofs come from one of two in-house sources: an Iris Inkjet digital proofer using Trans/4 software developed jointly with Scitex or the Kodak Approval system.

On the topic of training personnel to use digital photography equipment, Koser feels strongly that using photographers with traditional backgrounds, rather than scanner operators, is the path with the shortest learning curve. With Quad/Photo's emphasis on measured photography, digital camera operators refer to a standard set of lookup tables based on measured lighting values. Because of these values, said Koser, the highlight, midtone, and shadow placements are identical whether the image is captured digitally or on film. This similarity minimizes the likelihood of mistakes when a photographer moves between film and digital image capture, he added.

Koser noted that at Quad/Photo the calibrated tone reproduction curves are not changed at a photographer's whim. It is the photographer's responsibility, he said, to light each shot so that it conforms to the designated tone curve. If a particular nook in a product is lacking in shadow detail, the photographer must adjust the lighting to improve the shadow rendition rather than make an adjustment to the tone curve.

In discussing how job duties are divided among employees, Koser explained that while photographers operate cameras, the primary responsibility for gray balance and color correction rests with the color separators. A clear division of labor makes the technology less intimidating, says Koser. Although Quad's photographers know how to use lighting adjustments to facilitate color separation, they realize their most important contribution is adding visual interest to their shots through lighting and composition.

A secondary challenge posed by the introduction of digital photography services at Quad/Photo has been dealing with the occasional customer who is caught up in the glow of digital imaging technology regardless of its suitability for a particular project. Koser finds it far better to explain when digital photography is likely to generate results inferior to those produced by conventional film-based techniques, and to let the account go to a competitor if the customer is adamant. The risk of inferior results that could unnecessarily damage the company's hard-won reputation is not worth it, says Koser.

In selling measured and digital photography services, Quad/Graphics' sales staff often let the company's track record speak for itself by showing prospective customers samples from previous jobs. This, commented Koser, has often proved to be a more effective sales approach than attempting to convince a nontechnical customer of the advantages of a particular technology

Quad/Photo's initial investment in digital photography was about $50,000. This amount included a single Leaf DCB plus an accompanying Macintosh workstation for which Leaf recommended a minimum 64 MB of RAM and 300 MB of hard disk storage. Quad's existing photography studio already had suitable electronic flash lighting equipment, so no additional lighting was needed for the digital camera.

Since Quad/Photo's digital photography jobs are integrated into its overall photographic workflow from the outset, it was not possible, explained Koser, to track the return on investment period independently. However, the sales generated by digital photography for this fiscal year are expected to be close to 30% of Quad/Photo's total revenue. This represents a jump from 5% of total revenues for the preceding 12 months. Koser expects growth to taper off between 40% and 45% during the next year due to the inherent structure of Quad's photography business. Koser explained that because Quad's digital cameras use three-pass RGB image capture, jobs that include live models will still have to be shot with film until there is an advance in CCD technology.

Koser found that customers were initially reluctant to split a job between film and digital image capture, fearing appearance differences on the press sheet. But over the years, Quad/Photo's consistency between film and digital capture has allayed these worries and most customers now consider it routine to intermix still life shot with a digital camera and fashion shot with conventional film in the same project.

PRIMARY COLOR

Primary Color was an early adopter of digital image capture technology and one of the first to purchase the Leaf Digital Camera Back (Leaf DCB) in 1993 along with a Hasselblad medium-format camera. Of the work digital photographer Martin Brower now shoots for Primary Color with the Leaf DCB, 60% is for catalog clients; the remaining 40% is for advertising agencies. Less than 5% of his photography is film-based, says Brower, adding that during three years of steady day-to-day use, the Leaf DCB required only a single $200 outlay for repairs.

Digital photography is not marketed independently, but sold as a value-added option in conjunction with Primary Color's prepress and printing services. A typical CMYK file size is 10 MB, with image enlargement ranging from 100 to 200%. When very high resolution is required, rather than push the limits of the Leaf DCB, Brower shoots transparency film and has it scanned on one of Primary Color's Linotype-Hell drum scanners. Since Brower's studio is a short walk away, image files are transferred to the prepress department via hard-drive shuttles and data cartridges. A recently installed high-bandwidth T1 line is, however, seeing increasing use for digital image transmission.

Customer acceptance of digital photography reflects a Los Angeles market that is more mature than many regions of the United States, says Brower. The novelty of digital image capture is no longer a draw. Art directors and designers know who the digital photographers are and what their capabilities are. New clients come

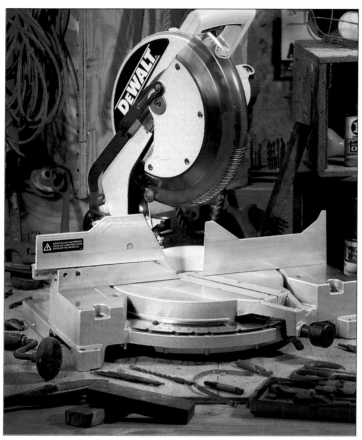

An otherwise static photograph of a cut-off saw comes to life with creative lighting. Martin Brower used the Leaf Digital Camera Back II for this image capture which produced an 18-MB CMYK/TIFF file. Note the use of a blue gel over the fill light to add visual interest.

to his studio at Primary Color, says Brower, because they want to use digital photography for a project. It isn't necessary to convince them of the merits of the technology. Clients realize it may be more efficient to shoot film and scan it for a project with a limited number of photographs. But for large jobs with many images, most customers know that digital photography can cut production time dramatically.

"We hand it to you ready to go. All you have to do is hit Print."

Martin Brower runs the digital photography department at Primary Color, Irvine, California.

In contending with the Leaf DCB's tendency to produce overly saturated red and orange hues, Brower developed a compensation system using Photoshop's color correction tools. He and an assistant handle color corrections on all digital image files captured with the Leaf. "We hand it to you ready to go; all you have to do is hit Print," says Brower. When a mistake is made in correcting a digital image file, he assumes the responsibility for troubleshooting and makes sure the problem is resolved. This approach, he adds, eliminates the finger-pointing scenario between photographer and color separator.

In the past, Brower experimented with an Iris Inkjet for intermediate proofing but, ironically, clients at times found the rendition too appealing. Occasionally, such a client would insist that an Iris proof be substituted for the Fuji Color Art contract proof. This dilemma, he said, hastened the refinement of a soft proofing solution.

Brower hasn't found the lack of a hard copy reference image to be a particular hindrance. He no longer uses intermediate digital proofs, but prefers to rely on a 19-inch monitor for soft proofing. Art directors, he explained, are well-acquainted with viewing layouts and images on a monitor, and Primary Color's Macintosh workstations are similar to the computers they use every day. Clients quick-

Cyan	Yellow						C-30	Y-28	Y-26	Y-24	Y-22	Y-20	Y-18	Y-16
C-7	Y-6	Y-5	Y-4	Y-3	Y-2	Y-1	M-28							
	M-6						M-26							
	M-5						M-24							
Magenta	M-4						M-22							
	M-3						M-20							
	M-2						M-18							
	M-1						M-16							
C-80	Y-78	Y-76	Y-74	Y-72	Y-70	Y-68	Y-66	C-60	Y-58	Y-56	Y-54	Y-52	Y-50	Y-48 / Y-46
M-78							M-58							
M-76							M-56							
M-74							M-54							
M-72							M-52							
M-70							M-50							
M-68							M-48							
M-66							M-46							

In grappling with the issue of color gamut representation on a monitor, Martin Brower and his colleagues at Primary Color found gray balance targets to be indispensable. Their method of determining the adjustments needed for each aim-point on the tone reproduction curve is described here. The targets shown above are from GATF's 25 × 38-in. Sheetfed Test Form.

ly learn that image captures displayed on a monitor provide useful feedback regarding composition and highlight/ shadow placement, but that color representation is not to be trusted. When layout tolerances are especially critical, Brower drops the image capture into a QuarkXPress page for the client to evaluate. For a visual record of a client's digital photographs, Brower sometimes does a screen capture of the thumbnail images displayed in Photoshop and outputs a color laser print.

In grappling with the issue of color gamut representation on a monitor, Brower said he and his colleagues at Primary Color have found gray balance targets to be indispensable. These targets take the form of quadrants in which a fixed dot percentage of cyan ink is overprinted with increasing dot percentages of magenta and yellow that cluster around an aimpoint on a tone reproduction curve. For five-point control—the most thorough method—five quadrants are used, corresponding to highlight, quarter-tone, midtone, three-quarter-tone, and shadow. Within each quadrant, the combinations of CMY are compared one-to-another to find the most neutral gray. For example, the aimpoints that GATF has calculated for internal production are 5C, 3M, 3Y for highlight; 30C, 25M, 25Y for quarter-tone; 60C, 50M, 50Y for midtone; 80C, 75M, 75Y for three-quarter tone; and 95C, 90M, 90Y for shadow.

At Primary Color, gray balance targets are scanned and output to separation film using a calibrated imagesetter. Plates are then burned and the targets are printed with four-color process inks on a fingerprinted, offset lithographic press. A press sheet containing the printed target is then photographed with the Leaf DCB, and the image capture of the gray balance targets is viewed on the monitor. Using the densitometer tool in Photoshop and CMYK display mode (as re-created with the monitor's RGB phosphors), the most neutral patch in each gray balance quadrant is read and compared with the original values to determine the adjustment needed for each aimpoint on the tone reproduction curve. This method, concludes Brower, provides a comprehensive solution to color gamut inconsistencies.

AMERICAN COLOR

While most prepress houses and trade shops have exercised prudence with their initial forays into digital photography, American Color leaped into the fray with a company-wide commitment. Digital photography workstations are in place and digital image capture is in full swing at seven locations around the United

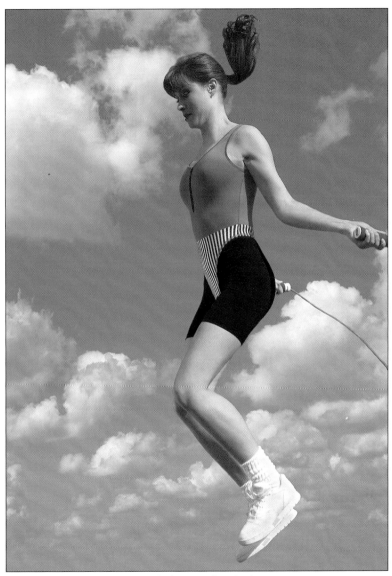

Until recently, high-quality digital photography of subjects in motion were not technically possible. The enhancements of the Kodak DCS 400 series, Leaf Catch Light, and soon-to-be-released MegaVision T-3 "single-pass" cameras have introduced motion into the digital paradigm. The model jumping rope was photographed with a Kodak DCS 460 camera, which produces a post-processing 18-MB RGB file in a single exposure.

"There are more exaggerations associated with digital photography than tall tales in the state of Texas."

John L. Carroll, an independent photographic consultant, specializes in photographic/prepress integration and in helping printing and retail businesses make the transition to digital photography.

States—Atlanta, Chicago, Dallas, Nashville, Phoenix, Santa Ana, and West Palm Beach. In all, American Color has 17 production facilities linked by a wide-area network (WAN) that just recently replaced its satellite network. The system has enough bandwidth to permit simultaneous transmission between any or all of these locations. Photographic images can be produced at remote locations and then streamed back to a central printing site, usually in Buffalo, New York, to produce the final printed product.

To synchronize these far-flung mechanizations, American Color employs a total studio group staff of 15, including photographers, stationed at its image-capture locations. A larger 60-member resource group provides support services, including computer and software expertise, color correction and image manipulation, and network maintenance.

John Carroll, former digital photography specialist at American Color, refers to the WAN as a nationwide virtual studio. He points out that when different elements of a photographic project can be handled in regional locations, it saves time and money that would otherwise be spent in amassing products, props, and talent for a centralized production. Major savings can also be had in transportation and shipping costs since nothing needs to travel except for the digital image files. American Color is perhaps the first vendor to

establish remote digital photography locations within client facilities.

American Color's Phoenix, Arizona, photography studio has a Leaf DCB and three Kodak digital cameras (a DCS 420 and two DCS 460s). Other locations are outfitted with MegaVision T2 capture stations and 1024 workstations. Carroll describes the Mega-Visions as real workhorses with a 50% productivity increase over conventional film image capture. Within the context of American Color's image processing procedures and formulas, he sees the MegaVision as having a slight resolution advantage over the Leaf DCB that uses the same CCD chip.

With the accompanying workstation, MegaVision images can be viewed in real time on a 17-in. RGB monitor. Lookup tables of algorithms for gravure, letterpress, and offset lithography can be stored and applied as needed for file conversion to CMYK. Scott Brazell in the Phoenix studio and Rick Rumley in the Chicago studio have developed several proprietary image processing programs that improve the odds of generating successful color separations without the need for additional correction during electronic prepress. For the typical product photo project, 96% of the CMYK image files need no further adjustment before output to separation films, said Rumley.

There are plenty of potential markets with the MegaVision's 12-MB file size and the Leaf digital camera backs, but Carroll sees the opportunity to adapt high-resolution scanning backs, such as the Dicomed and Photo Phase, to a new clientele. These include fine art reproductions, ranging from those sold by museum shops and galleries to high-end retail catalogs where accurate reproduction is increasingly important. Since high-resolution scanning backs frequently require specialized high-intensity (HMI) lighting to achieve reproduction-quality results, many photographers hesitate to make the additional investment. Carroll notes, though, that recent improvements in anti-flicker tungsten lighting have made it possible to use the hot lights familiar to an older generation of photographers.

For location photography projects, Carroll and his team rely on two MegaVision 1024 workstations based at the Chicago facility. They have proved to be surprisingly portable, he says. This equipment is also occasionally loaned to other American Color photography facilities when bottlenecks arise due to unexpectedly large projects. As part of its facilities management effort, American Color is currently installing an image capture station and two or three digital cameras at a client's New Jersey facility.

American Color formed a relationship with the digital camera vendor, MegaVision, in 1988 when its founder, Ken Boydsten, was hawking his Tessra Megavision T1 prototype with the help of a few friends. Four years later, MegaVision is a major player in the digital photography market. Carroll jokes that his equipment requests to the company's Santa Barbara, California, headquarters were once promptly fulfilled, but these days there is a three- or four-week waiting list.

As American Color has expanded its digital photography operations, finding qualified personnel has become an ongoing challenge. Carroll said he has had success hiring recent photography school graduates, whom he relies on for skills in traditional photographic lighting techniques. This background, he said, serves as a helpful foundation for acquiring an understanding of digital imaging and electronic prepress necessary to complement the skill set of an aspiring digital photographer. Carroll has found that printers and prepress technicians often lack the intuitive understanding of photographic lighting necessary to produce high-quality imagery.

SUMMARY

Successful long-range business plans depend on having a clear vision of how a technology is likely to evolve. As these tales from the turf have shown, digital photography has the potential to pay off handsomely for printers and graphic arts professionals who have already embraced digital photography in its early stages, investing in facilities, equipment, and skilled personnel.

With the widespread use of Leaf Digital Camera Backs and the growing popularity of the MegaVision T2, the equipment riddle appears less complicated than a first glance would suggest. But, a new wave of digital cameras, led by the Dicomed Bigshot digital camera back with the ability to capture ultra-high resolution RGB images in 1/300th second, may soon stand the current paradigm on end. The revolution is at hand.

Before making an equipment purchase, consider who is going to operate your digital camera and diligently integrate the gargantuan image files into your existing workflow. Based on the unanimous experience of these four printers and prepress shops, a displaced scanner operator probably won't be your first choice. Recent photography school graduates appear to have a new palette of employment options. This viewpoint underscores the fact that a digital photography venture is more likely to succeed if the photographer brings creative talent to the table. As printers have seen first hand with digital printing presses, customers don't make buying decisions based on whether the product is produced with cutting edge technology. Their underlying concern is still quality, and photography buyers aren't taking shortcuts.

Less obvious than equipment and personnel considerations is the infrastructure of your prepress department, specifically the networks that will be used to transmit digital image files. Macintosh workstations used for digital image capture require large amounts of RAM and vast storage space, either on hard drives or removable media. While the "sneakernet" approach may suffice for internal work, increasingly photo-intensive projects and the need to transfer image files between remote locations will lead to growing dependence on T1 lines and fiber optic transmission networks. High bandwidth is imperative to minimize transmission times and avoid workflow bottlenecks.

Based on the experiences of the four photographers interviewed here, it is apparent that digital photography does offer new turf for printers. The potential applications for digital image capture con-

tinue to expand. And a new wave of digital cameras—with single-exposure, high-resolution, RGB image capture—is poised to carry entrepreneurial printers into the next millennium.

3 Management Considerations

HE advent of digital image capture may be the most important development in photography since the introduction of color film 60 years ago. Digital cameras are rapidly gaining acceptance in the publishing industry and the markets it serves. From the printer's perspective, digital photography is evolving into the new "front end" for color imaging workflow.

In its many current manifestations, the digital camera is a niche imaging tool. By the turn of the century, it is expected to be utilized by 25% of imaging markets. Within 10 years (2005), 75% of all commercial images might well be captured digitally. Currently, digital photography is used for approximately 4% of the retail and catalog images that could be captured digitally with existing technology. This market includes inserts, ROP (run on press), and the majority of direct mail and catalog publications. The upscale catalog market may be waiting for the next generation of digital cameras, but today's technology and applications are already poised to address the quality, workflow, and cost containment needs of catalog publishers and other segments of the printing industry.

Marketplace interest in digital photography has doubled within the last 18 months. This trend is projected to continue for the next decade, leading us into the 21st century. If we calculate this spiral, digital image capture will encompass 25% of the retail and catalog market by the year 2000. Some futurists foresee product introductions such as Dicomed's 4k × 4k CCD chip and liquid crystal filter technology as creating an explosion that will accelerate demand to 50% or more. Whatever model is accepted, one fact is clear—digital photography will be the predominant imaging technology.

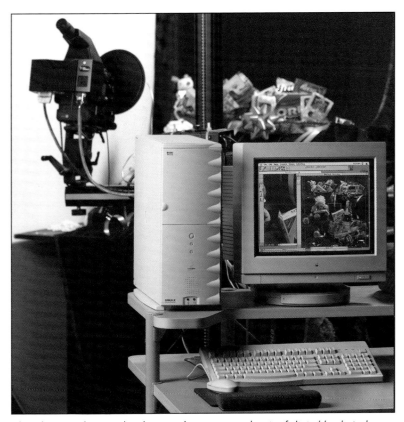

This photograph was taken by a studio camera with a Leaf digital back. It shows a digital camera in the process of capturing a food giftware composition. The image you see on the monitor is what the camera in the background is actually capturing. The camera in the background is a Fuji GX680 with a Leaf digital back with a tri-color wheel. This digital photo within a digital photo was provided compliments of PGI Studios, Oklahoma City, Oklahoma.

Despite these projections and the real growth of digital photography within the last few years, the supply side of digital imaging has yet to realize a clear leader in driving the technology's application and integration. To date, the prepress industry has outpaced the photographic industry in terms of digital camera installations. Differences in trade practices and philosophy have, however, created a temporary ceiling for both.

Is the quality good enough?
Yes...

Two years ago digital photographers compared the quality of their images to 35 mm Kodachrome slides. Today, we regularly make side-by-side comparisons between high-end 2k × 2k digital image captures and 4 × 5 in. transparencies scanned and output at 150 lpi viewed as Matchprints. This is not recommended for the novice though, since real expertise and a touch of artistry with a digital camera are required to pull this test off.

AESTHETIC VS. TECHNICAL ORIENTATIONS

Photographers bring a refined set of aesthetic values to digital image creation, but the "print ready" quality of the resulting image files frequently falls short of film-based benchmarks. Prepress and printing companies who have expanded their production capabilities by offering digital photography services have often failed to deliver images with the creative spark that is second nature to commercial photographers.

The blending of creativity with technical expertise is complicated by the marketing efforts of the two diverse but interdependent disciplines. The graphic arts industry is production oriented, while the photographic industry is deeply rooted in "talents" and in brainstorming abstract concepts into visual realities. Both, however, rely on visual media and strong vendor/client relationships because of the collaboration needed to produce the final product. Most of the jobs undertaken by commercial printers involve printing to match reference proofs. The product must meet exacting color specifications. Commercial photographers, in contrast, are often beholden to an art director's layout. Strong photographs evolve from give-and-take, based on technical limitations and aesthetic judgment, between art director and complementary photographer.

The right fit between photographers and printers will emerge as both the aesthetic and technical disciplines achieve true process

integration. Both will bring complementary values to the relationship in a more interwoven environment. In time, the marketplace and practitioners will grow to embrace this new blend of image creation, prepress, and printing.

THE INTEGRATION OF PHOTOGRAPHY AND PRINTING

A decade ago Karl Koch, founder of Sinar, reintroduced the concept of measured or "4 f/stop" photography based on the black-and-white zone system conceived by Ansel Adams in the 1940s. He advocated that photographers work with a managed tonal range tailored to the range that could be held on a press sheet. This mini-

The following information from Editor & Publisher *(October 26, 1996, p. 26) gives one indication of how quickly digital photography is being adopted.*

Associated Press
New York

Ten digital cameras for the Fort Lauderdale Sun-Sentinel and another ten for the Tulsa World.

To capture late-breaking sports action and other spot news assignments, Fort Lauderdale bought eight NC2000e cameras (jointly developed by the AP and Kodak using a Nikon body) and two Canon EOS DCS3c cameras, also using an electronic Kodak back and offered by the AP.

Tulsa World, the first U.S. daily to convert entirely to digital photography, said it will no longer process film when it equips each photographer with an NC2000e, a laptop computer to acquire, preview and caption images, and a cellular modem to transmit pictures from any location. Several World staffers have been using the cameras exclusively since March 1996, when digital images from a late-night NCAA basketball championship game were able to make the first edition. All photographers were to have an NC2000e by September 1996.

Are digital photography capabilities in your future?
Without doubt...

Even if you think you are "years away" from making the digital transformation, it is prudent to start the learning curve and understand what the front runners are doing. The future of photography, prepress, and publishing are tied to digital cameras. The real question may be: Is mainstream prepress positioned for the future or will it go the way of process camera practitioners?

mized the need for subsequent tone compression during color separation. It also resulted in greater client satisfaction because the press sheet reproductions bore a closer resemblance to their original transparencies. Photographers who mastered measured photography furnished their clients with images that reproduced as well as, if not better than, they appeared on the light box. This was the beginning of the journey toward understanding the processes that affect the true value of transparency reproduction on the press sheet.

Digital photography is an extension of measured photography, in that it requires similar control of tonal range via highlight, midtone, and shadow placement. Many high-end digital cameras are adept at capturing a more extended tonal range than that of their film-based counterparts. But, aside from providing greater exposure latitude, the additional tonal information must still be compressed to fit the narrow density range held on the press sheet.

As with film, effective use of a digital camera requires that the photographer light the subject to a predetermined tonal range. If this is not done, the image files displayed as histograms on the monitor screen are subject to severe tone compression imposed by the associated imaging software. Photographers are finally discovering what color separators have known for years—that control of tonal range on the set is essential to high-quality reproduction of a photograph.

INITIAL ROI CONSIDERATIONS

The path that will allow us to realize the full potential of digital photography is cluttered with obstacles. Besides the conundrum of aesthetically oriented photographers versus technically oriented printers, there is a lack in understanding the values that digital photography brings to the market. Most clients, photographers, and printers are using tunnel vision to analyze the big picture that is digital photography.

This oversight is largely based on an erroneous assessment of economic factors. High-end digital cameras are expensive. The technology changes and improves almost weekly. There is fear that investing capital resources in digital cameras today will be akin to investing in tomorrow's obsolescence. What prospective participants have failed to analyze is the dollar return they can reap between today and tomorrow.

...For Photographers

When one considers the investment needed to get into digital photography relative to specific workflow, a digital camera system can achieve a return on investment in six months. For studios that

Will the cost of digital cameras start to drop?
Yes and No...

The cost of new releases and technologies will most likely continue to rise based on continuous R&D investments. As new technologies come to market and camera production attains efficiency of scale, existing technologies will experience price adjustments that reflect their utility in the new hierarchy. We can also expect to see the development of a "pre-owned" market for equipment that is to be retired in favor of newer offerings. The cycle will continue as developers chase the ultimate reference for commercial image quality, 8 × 10-in. transparency film, over the span of several decades.

A Word of Caution... Digital Photography is More than an MIS Decision

Small and medium-sized printers and graphic service providers who want to adopt digital photography should not depend solely on the advice—abeit well-intentioned—of MIS groups and system integrators, whether internal or external. They know their digits well, but tend to have a narrow view of the digital imaging world and can lack the industry expertise to specify the proper cameras and software and train personnel. A number of operations who followed this route have found that their time, effort, and money has been misspent. One such operation was advised to buy a Polaroid digital camera for studio images of still life and fashion. Another ended up investing more than $100,000 for a complete Leaf system for images that don't exceed 3 x 3 inches at 120 lpi.

Smaller and medium-sized operations need to take a team-based approach to successfully outfitting a digital studio, integrating all the related processes into their workflow, and ultimately producing print-ready CMYK files at the best investment dollar per image. The digital photography transition needs a "three-legged stool" combination of expertise and application backgrounds, including (1) system integration or MIS expertise; (2) prepress/image processing/printing experience; and (3) digital camera/photography knowledge.

System integrators or MIS personnel can be an important link for workstation hardware procurement and service, but are best not involved in decisions that affect the capture or processing of image files downstream.

The prepress or printing resource should specify the software applications and calibrations that will generate print-ready image files that are matched to printing needs. The prepress/printing partner can offer system calibration (color management) that goes beyond just a "system-oriented" operation.

Unbiased advice about selecting a digital camera can be harder to find. Digital camera sales representatives are adept at making

> *their camera "the best solution available," but not necessarily in relation to your true needs regarding capacity and price. There is no single best digital camera. A number of digital cameras can probably satisfy your needs now and at least two years into the future. You may want to consult a specialist who is nonaligned with any digital camera manufacturer and who regularly tracks and tests all kinds of digital cameras and technologies. You need to evaluate your real digital photography needs and workflow, not just a camera's features. Digital photography needs to produce the best possible image to satisfy the customer while also producing print-ready CMYK files at the best investment dollar per image.*
>
> *John L. Carroll*

produce high-volume insert or catalog work, the basic costs of film, processing, and Polaroid proofs will pay for the digital system in about eight months. Add in the time savings from reduced reshoots, holding sets for verification, and trips back and forth to the processing lab and the ROI falls to six months. In view of these benefits, even if the camera becomes obsolete after one year, the cost savings will have returned twice on the initial investment.

Digital photography not only allows photographers to save money by eliminating the expense of consumables, it also facilitates the sale of services at a premium. The photographer is selling images that are color separated and digitized, so prepress savings from the elimination of scanning and the reduced need for color correction can be substantial. The photographer could add a percentage of the previous scan-to-disk fee, thereby generating additional value from every digital image. With the elimination of consumable expenses, including Polaroids, film, and processing, and with the addition of restructured color separation fees, the investment in a digital camera can be made up in short order.

When is the best time to become involved with digital photography?

Now...

Digital photography is not based on a single technology or camera type. If your plans include digital photography services within the next year, it is wise to begin scoping out various cameras, software applications, technique enhancements, and market needs today. Your primary area of study should focus first on market needs, basing all other decisions on what your market will expect from digital photography.

...For Prepress Operations

Where will prepress operations derive income? The answer is image processing.

Digital photography will be increasingly used for image-intensive product catalogs and inserts, reducing the need for prepress adjustments. Specialized advertising photographers will continue to shoot film-based images for high-end catalogs and upscale print advertising. As they make the transition to digital photography, these users are less likely to perform post image-capture adjustments. Advertising agencies engaged in high-end print work have deeper pockets and more critical production specifications. This opens the door for prepress specialists whose business is image optimization for print. They can take the photographers' raw RGB files, make corrections, and deliver "print ready" CMYK files for output and proofing. Although prepress houses will have lost income from digital photography's bypass of the scanning function, opportunities remain to do color correction, gray balance, unsharp masking, and tone curve adjustments to optimize the color separations. In some cases, image processing functions can be highly automated, thus reducing labor expenses and compensating for lost scanning revenue.

Off-the-shelf color conversion packages, used by most digital photographers, leave much to be desired in converting RGB images to CMYK. To achieve high-quality camera file conversions, the RGB image must be conditioned to counter the reduced color sampling of scanner algorithm conversion packages. This provides another impetus for photographers to develop relationships with quality prepress houses.

Image processing of digital camera files is more than "plug and play" or "point and click." An in-depth understanding of color theory is needed to create profiles and tables that maximize image quality. Furthermore, most photographers have little, if any, understanding of UCR (undercolor removal) and GCR (gray component replacement) and of how proper curve selection will impact the reproduction for various printing processes, paper stocks, and ink sets. Unsharp masking also requires a more sophisticated application than just clicking the appropriate icon in Photoshop. The kind of subject matter and its reproduction size affect the desired amount of unsharp masking.

When properly captured and processed, though, images from digital cameras will challenge those produced by film and scanning for many applications.

If I invest today, will my equipment be obsolete in six months?
Probably not...

Most of the present enhancements in digital photographic technology have been software driven. Certainly, the new 4k × 4k CCD chip will raise the bar, but it could be overkill for many current applications. If this applies to your market niche, then existing cameras and technology can be used indefinitely. In a number of current applications, only 50 to 80% of the resolution of a 2k × 2k chip is required to deliver optimum images.

...For a Strategic Alliance

Prepress shops and printers who have invested in digital camera equipment can find it advantageous to "partner" with a respected photographic talent in their market. The prepress shop or printer will have a more creative and pleasing product to sell. The photographer will gain an avenue to transfer his/her creative talent to a new technology. Whether the prepress shop/printer brings the photographer in-house or forms a strategic alliance with a studio, both will profit from the merger of aesthetic and technical expertise.

THE REAL SAVINGS

While reduction of studio-based consumables and lower prepress costs are the most commonly cited reasons for a quick ROI, the big savings are client-based and workflow-driven. Digital photography allows clients to have their "position files" immediately. No time is lost waiting for transparency processing, reshoots, or scanning. A client can literally leave the studio with a disk of FPO (for position only) files for page layout. High-resolution print ready files generally follow in a day or two. Any file naming conventions that would cause confusion or redundancy during subsequent downstream processes can be avoided if the studio assigns and embeds the names as the digital image files are created.

What are the real benefits of this new workflow? Most important is a dramatic decrease in overall production cycle time. Many clients report less in-house overtime and fewer weekends needed to complete jobs.

Digital cameras provide the perfect tool to facilitate eleventh-hour merchandise changes with fewer rush charges for vendor overtime. Time has become the currency of the 1990s, and digital photography is the image capture technique that slashes time out of the production cycle.

NEW RESPONSIBILITIES

With the emergence of a new imaging paradigm, the apples-to-oranges comparison of film-based dyes to process inks on a press sheet will no longer be a point of contention. Digital photography practitioners, however, are confronted with additional responsibilities. It will soon be insufficient to merely deliver transparencies to a client. With digital image capture, photographers are likely to become accountable for how an image prints, rather than how the transparency appears on a light box. Digital photographers are already delivering CMYK digital proofs to clients for approval. Look for this shift in responsibility to eliminate the disparity between original art and contract proofs that has plagued commercial printers for decades.

WHAT WILL DRIVE DIGITAL PHOTOGRAPHY?

Marketplace demand will drive digital photography. Retail and catalog markets are increasingly aware of the advantages afforded by digital photography. As more retailers adopt digital image capture to produce print advertising, their competitors must do the same in order to stay even. As digital photography becomes recognized as a competitive advantage in the marketplace, it will evolve into a competitive necessity among photographers and other providers of image capture services. Those without digital photography capabilities will have fewer business opportunities.

Technology will not drive digital photography. Rather it will stimulate the marketplace to use digital photography for more and more imaging applications. Marketplace needs will generate the demand for digital photography developers and integrators to create the equipment, techniques, and skill sets necessary for expanding digital image capture into portraiture, fashion, and print advertising production.

WHO WILL OCCUPY THE TURF?

The graphic arts industry is in the process of re-inventing itself. As image digitization via drum scanning is usurped by digital cameras and desktop scanners, a new production workflow is evolving in response to the shifting image capture paradigm. It appears likely that the graphic arts industry will lead the charge and eventually control the market.

As digital photography becomes the new front end for the digital publishing environment, integration will be achieved with full electronic prepress (including digital contract proofing) and computer-driven engravers and platesetters. The digital workflow loop will be completed. Printers and prepress houses will recognize a vested interest in holding all the assets.

Among industry leaders, the facilities management offerings include not only digital cameras, but also full-scale photography studios. The approach is to carefully analyze a client's needs and workflow, then tailor a facilities management package with complementary capabilities. As with the graphic arts industry as a whole, digital photography has changed the makeup of facilities management offerings. We have gone from desktop publishing and onsite prepress to installations that offer cohesive, integrated imaging capabilities.

Progressive facilities management groups can benefit from forging strategic alliances not only with their clients, but increasingly with the clients' photographic resources. A digital photography alliance may, for example, include consulting services covering equipment and workflow or the actual placement of digital cameras and image processing equipment at designated studios.

In today's environment, the image creator has the upper hand in servicing clients and the market as a whole. Emerging trends place a premium on control of the camera, controlling, in essence, the means to create the message. Major players in the graphic arts industry are already integrating digital photography with high-

speed and large-capacity transmission capabilities. Using powerful image databases, they can control photographs from creation through archival management. You can bet they are reaping a pay-off from their digital imaging turf.

Glossary of Terms

Area array. CCD sensors with 2-dimensional grids of photosites. The use of three monochrome matrix arrays, or a single matrix with photosites that are alternately coated with RGB filters, allows a complete image to be captured instantaneously.

Bit depth. The number of pixels used to represent each pixel in an image, determining its color and tonal range.

Camera back. The portion of a graphic arts camera that secures the photographic medium in place. In conventional photography, the camera back houses film or photosensitive paper. In digital photography, the camera back transfers the digitally captured image to either an internal storage device or to an external hard drive.

Charge-coupled device (CCD). An integrated, micro-electronic light sensing device built into some image-capturing devices.

CMY. Stands for cyan, magenta, yellow, the three process colors. They are combined with black (K), in a system of superimposed printing to provide a full range of colors.

Depth of field. The distance range between the nearest and farthest objects that appear in acceptably sharp focus in a photograph.

Distortion. In camera lenses, any departure from the proper perspective of an image. In photography and platemaking, a departure in size or change in the shape of a reproduction when compared to the original.

Fiber optics. A data transmission medium. Cables are constructed from strands of glass or plastic and surrounded by protective insulation, and support nearly error-free transmission of multimedia traffic encoded as pulses of light traveling at speeds in excess of 100 Mbps.

Focal length. The distance between the optical center of a lens and the point at which an object image is in sharp or critical focus.

F/stop. Fixed sizes at which the aperture of the lens can be set. The values of the f/stops are determined by the ratio of the aperture to the focal length of the lens.

Gray balance. The values for the yellow, magenta, and cyan that are needed to produce a neutral gray when printed at a normal density. When gray balance is achieved, the separations are said to have correct color balance. Gray balance is determined through the use of a gray balance chart.

Gray balance chart. A printed image consisting of near neutral grid patterns of yellow, magenta, and cyan dot values. A halftone black gray scale is used as a reference to find the three-color neutral areas. The dot values making up these areas represent the gray balance requirements of the color separations. The gray balance chart should be produced under normal plant printing conditions.

Gray component replacement (GCR). The process of reducing the smallest halftone dot in areas where yellow, magenta, and cyan all print, together with quantities of the other two colors sufficient to produce a neutral gray, and replacing that neutral with black ink

Halftone. Image in which the range of tones consists of dots of varying area but of uniform density. Creates the illusion of continuous tone when seen at a distance. The normal imaging technique for reproducing tones by lithography, letterpress, flexography, and screen printing

Image capture area. The actual area of the image after photographing, in contrast to the live image area. CCDs tend to make the image capture area smaller than the actual format of the camera.

Linear array. CCD sensor normally containing a red-, green-, and blue-filtered row of photosites. Linear arrays are scanned across the image area by a stepper motor.

Live image area. The potential dimensions of the film area that can be imaged by a camera.

Local-area network (LAN). A group of computers linked over a relatively small geographic area.

Nyquist Criterion. Theorem that requires two pixel samples for each line of resolution in order to maintain high quality of digital color reproduction. Minimum image resolution needed is equal to the image dimensions multiplied by twice the line screen ruling.

Optical disk. A form of data storage in which a laser records data on a disk that can be read with a lower-power laser pickup.

PC card. Storage medium in digital cameras and camera backs.

RGB. Stands for red, green, blue, the three primaries of additive color theory. Wavelengths of the three colors can be added in various proportions and combinations to produce a full range of colors.

SCSI. Abbreviation for small computer systems interface. A computer port used to link the machine with external peripherals.

T1 line. AT&T specification for high-bandwidth, leased digital transmission. Unlike a switched line for which one pays just for the time required to complete a transmission, T1 lines are dedicated to continuous data transfer. T1 lines allow data transfer at 1.544 Mbps.

Undercolor removal (UCR). A technique used to reduce the yellow, magenta, and cyan dot percentages in neutral tones and replace them with increased amounts of black. UCR allows the same visual density with a lower total ink coverage.

Wide-area network (WAN). The linking of two or more related local-area networks (LANs) across a great distance, such as from one state to another.

Further Reading

"1996 Prepress Survey: Analog Slips Away," *Publishing and Production Executive,* vol 10 no 4, April 1996, p 28-30.

"APS Paves the Way" by Alexis Gerard, *Color Publishing,* vol 6 no 5, September/October 1996, p 12-13.

"Aviation Week Beats Clock with Digital Photos" by Paul Benson, *Color Publishing,* vol 6 no 4, July/August 1996, p 34.

"Buyer's Guide: Decent Exposure [Digital Cameras]" by Barry Green, *Publish,* July 1996, p 69-72, 74, 76-78.

"A Cadaver in the Camera?" by Alexis Gerard, *Color Publishing,* vol 5 no 4, July/August 1995, p 15.

"A Cadaver in the Camera? Part Two" by Alexis Gerard, *Color Publishing,* vol 5 no 5, September/October 1995, p 12, 14.

"The Calm before the Storm" by Alexis Gerard, *Color Publishing,* vol 5 no 2, March/April, 1995 p 11.

"Capturing the Wild Image" by Wayne Jebian, *Pre,* vol 7 no 4, July/August, 1995 p 30-32, 35.

"[Digital] Camera Man," *Pre,* vol 8 no 2, March 1996, p 27-28, 30, 32, 34.

"Digital Cameras Offer Printing Shortcuts" by David Lindsay, *Printing Journal,* vol 23 no 2, February 1996, p 1, 6.

"Digital Cameras Reshape Prepress" by Hadley Sharples, *Graphic Arts Monthly,* vol 68 no 7, July 1996, p 36-38, 40.

"Digital Cameras Wed Photo and Print" by Hadley Sharples, *Graphic Arts Monthly,* vol 67 no 6, June 1995, p 45-46, 48.

"Digital Photography," *1995 Technology Forecast,* [supplement to *GATFWorld,* January/February 1995] p 5–7.

"Digital Photography," *1996 Technology Forecast,* [supplement to *GATFWorld,* January/February 1996] p 8–10.

Digital Photography: A Hands-On Introduction by Philip Krejcarek, 282 pages, black and white, illustrated, plus CD-ROM with 100 images, 1997. Delmar Publishers, 3 Columbia Circle, Albany, NY 12212-5015.

"Digital Photography Advances Create New Opportunities," *Color Publishing,* vol 6 no 6, November/December 1996, p 12-14, 16, 18-21.

"Digital Photography: Catching the Shutter Bug" by Alex Hamilton, *Printing Impressions,* vol 39 no 1, June 1996, p 42-43, 50.

"A Digital Photography Tutorial [a review of the TAGA presentation with this title]" by Miles Southworth, *Ink on Paper,* June 1996, p 4-5.

"Digital Photography—Creating Improvements for Flexo Printing" by Marion Taylor, *Flexo,* vol 21 no 2, February 1996, p 16-18, 21.

"Digital Snap Shots" by Debbie Petersen, *American Printer,* vol 216 no 6, March 1996, p 38-42.

"Expanding Beyond Prepress," *Print on Demand Business,* May/June 1996, p 12.

"Film's New Format: a Boost to Digital?" by Alexis Gerard, *Color Publishing,* vol 6 no 4, July/August 1996, p 10-12.

"Filmless Photography Finds Its Niche" by Bob Adams, *Publishing and Production Executive,* vol 9 no 6, July 1995, p 20, 29-31.

A Guide to Digital Photography, Agfa educational publication, four-color, illustrated, 32 pages, 1996. $10 plus shipping from Agfa. Phone 800-395-7007; fax 847-296-4805.

"An On-Web Antarctic Trek: Digital Stills for Near Real-time Virtual Travel" by A. Victor Goodpasture, *Advanced Imaging*, vol 11 no 2, February 1996, p 36-38.

"Polaroid's Window of Opportunity" by Alexis Gerard, *Color Publishing*, vol 6 no 2, May/June 1996, p 13, 14.

"Product Review: A Back for the Future—Scanview's Carnival" by Mikkel Aaland, *Pre*, vol 8 no 4, June 1996, p 47.

"Push-button Color" by Frank Cost, *Ink on Paper*, March 1995, p 1-6.

"A Snap Shot of Digital Photography" by Stephen Schettini, EC&I *[Electronic Composition and Imaging]*, vol 10 no 1, April 30, 1996, p 20, 22-25.

"Software Is the Secret of Data Capture [Scanners and Digital Cameras]" by Marion Wilson, *British Printer*, vol 159 no 4, April 1996, p 23, 26, 28.

"Specialized Lighting for Big Pre-Press Digital Photography" by Al Fisher, *Advanced Imaging*, vol 11 no 9, September 1996, p 72-73.

"Status of Printing Technology—[Part] I" by Michael H. Bruno, *What's New(s) in Graphic Communications*, no 120, January-February 1996, p 2.

"Trends: Goodbye, Kodachrome" by Ira A. Gold, *Color Publishing*, vol 5 no 3, May/June 1995, p 9-10.

"Well Stocked [Royalty-Free Digital Images]" Barry Green, *Publish*, May 1996, p 49-60.

"Whatever Happened to Camera-ready Art?" by Raymond Flatt, *Flexo*, vol 21 no 2, February 1996, p 74-77.

About the Authors

David L. Milburn is a freelance corporate/editorial photographer with a keen interest in optimization of photographic images for print. Milburn's 15-year career in photography began with a degree in Industrial/Scientific Photography from the Brooks Institute of Technology. He completed his MS in Graphic Arts Publishing at the Rochester Institute of Technology in 1993, where he was an adjunct professor of "Prepress to Publication."

Eight years of freelance experience give Milburn credits in corporate, editorial, and catalog publications such as Browntrout Publishers, Electronic Learning, Elliot Calendar, Macys, the National Park Service, and View Camera.

John L. Carroll, an independent photographic consultant, has over 30 years of experience in commercial photography. His involvement with digital photography began in the mid-1980s while he was photographic director of the Alderman-Dallas Studio, Texas. He continued to develop digital expertise as founding photographer and photographic director at Omega Studios, Irving, Texas, and as digital photography specialist with American Color. He uses his experience to help businesses with photographic/prepress integration, and with setting up and operating the infrastructure necessary to digital photography.

Carroll studied photography, art, and design at Kansas State College and Rochester Institute of Technology. He began his career in photographic studies at Hallmark Card, Inc., where he was influenced by Hallmark's philosophy that the viewing box is not the determination of quality photography and that true image quality is determined on the printed page.

About GATF

The Graphic Arts Technical Foundation is a nonprofit, scientific, technical, and educational organization dedicated to the advancement of the graphic communications industries worldwide. Its mission is to serve the field as the leading resource for technical information and services through research and education.

For 73 years the Foundation has developed leading edge technologies and practices for printing. GATF's staff of researchers, educators, and technical specialists partner with nearly 2,000 corporate members in over 65 countries to help them maintain their competitive edge by increasing productivity, print quality, process control, and environmental compliance, and by implementing new techniques and technologies. Through conferences, satellite symposia, workshops, consulting, technical support, laboratory services, and publications, GATF strives to advance a global graphic communications community.

The Foundation publishes books on nearly every aspect of the field; learning modules (step-by-step instruction booklets); audiovisuals (CD-ROMs, videocassettes, slides, and audiocassettes); and research and technology reports. It also publishes *GATFWorld,* a bimonthly magazine of technical articles, industry news, and reviews of specific products.

For detailed information about GATF products and services, please visit our website at http://www.gatf.lm.com or write to us at 200 Deer Run Road, Sewickley, PA 15143-2600. Phone: 412·741·6860.

Other Books of Interest from GATF

The Graphic Arts Technical Foundation (GATF) is a major publisher of books on printing and related topics. Some of GATF's more popular titles include:

- **Understanding Digital Color**
 by Phil Green

- **Guide to Desktop Publishing**
 by James Cavuoto and Steven Beale

- **On-Demand Printing:**
 The Revolution in Digital and Customized Printing
 by Howard Fenton and Frank Romano

- **Understanding Electronic Communications:**
 Printing in the Electronic Age
 by A'isha Ajayi and Pamela Groff

- **Glossary of Graphic Communications**
 compiled by Pamela Groff

- **Professional Print Buying** edited by Phil Green

- **Handbook of Printing Processes**
 by Deborah Stevenson

- **Screen Printing Primer**
 by Babette Magee

- **Flexography Primer**
 by Donna Mulvihill

- **Lithography Primer**
 by David Saltman and Nina Forsythe